CREDITS
Cover : © Andrey Korshenkov/Shutterstock
Interior : p. 1, 4, 6, 9, 51 : © Clara/Shutterstock ; p. 2, 10, 25, 32, 42, 43, 58, 70 : © Amicabel/Shutterstock ; p. 3 : © Troyka/Shutterstock ; p. 5 : © Hibrida/Shutterstock; p. 7: © zubarevid/Shutterstock; p. 8, 21, 22, 66 : © cepera/shutterstock; p. 11, 13, 20, 27, 36, 38, 59, 67 : © Mark Grenier/Shutterstock; p. 12, 14, 15 : © Goldenarts/Shutterstock ; p. 16, 19 : © VectorRay/Shutterstock ; p. 17, 33, 39, 48, 50, 54, 63, 64, 71, 72 : © Andrey Korshenkov/Shutterstock ; p. 18 : © Katy_Katerina/Shutterstock ; p. 23 : © Login/Shutterstock ; p. 24, 37 : © Stephen Clark/Shutterstock ; p. 26 : © Yurkina Alexandra/Shutterstock ; p. 28, 29, 35 : ©CVADRAT/Shutterstock ; p. 30, 31, 49, 61 : ©Vasilus/Shutterstock ; p. 34 : © Slanapotam/Shutterstock ; p. 40 : © Objowl/Shutterstock ; p. 41, 44 : © iconizer/Shutterstock ; p. 45 : © redicka/shutterstock : p. 46 : © Kanna A/Shutterstock : p. 47, 57, 60, 62 : © eurovector/Shutterstock ; p. 52 : Curly Pat/Shutterstock ; p. 53 : © Essl/Shutterstock ; p. 55 : © Casejustin/Shutterstock ; p. 56 : © ananas/Shutterstock ; p. 65 : © Swill Klich/Shutterstock ; p. 68 : © USBFCO/Shutterstock ; p. 69 : © Cartone Animato/Shutterstock.

An Hachette UK Company
www.hachette.co.uk

First published in France in 2015 by Dessain et Tolra

This edition published in Great Britain in 2015 by Hamlyn, a division of Octopus Publishing Group Ltd
Carmelite House, 50 Victoria Embankment, London EC4Y 0DZ
www.octopusbooksusa.com

Copyright © Dessain et Tolra/Larousse 2015
English translation © Octopus Publishing Group Ltd 2015

Distributed in the US by Hachette Book Group
1290 Avenue of the Americas, 4th and 5th Floors,
New York, NY 10020

Distributed in Canada by Canadian Manda Group
664 Annette St., Toronto, Ontario, Canada M6S 2C8

ISBN 978-0-600-63299-3

Printed and bound in China
10 9 8 7 6 5 4 3 2 1

Publishing directors: Isabelle Jeuge-Maynart, Ghislaine Stora
Editorial direction: Stéphanie Auvergnat, Florence Pierron-Boursot
Editor: Barbara Janssens
Cover: Fanny Tallégas, Abigail Read
Layout: Fanny Tallégas
Senior production manager: Katherine Hockley